Veronica Wollaughly
Hornsea bookshop
14/09/11

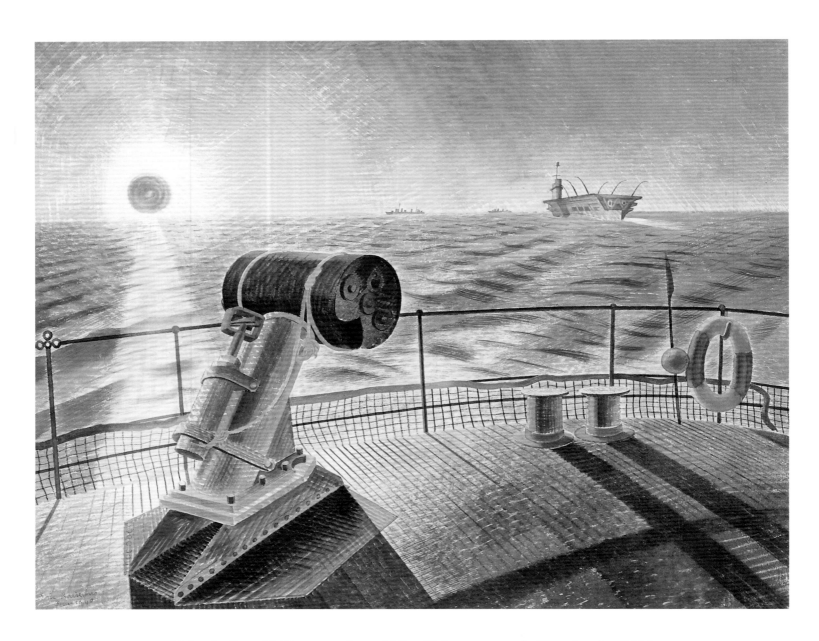

Midnight Sun, 1940, watercolour, 47.0 x 59.1 cm, copyright Tate, London 2010.

James Russell

RAVILIOUS IN PICTURES
THE WAR PAINTINGS

The Mainstone Press

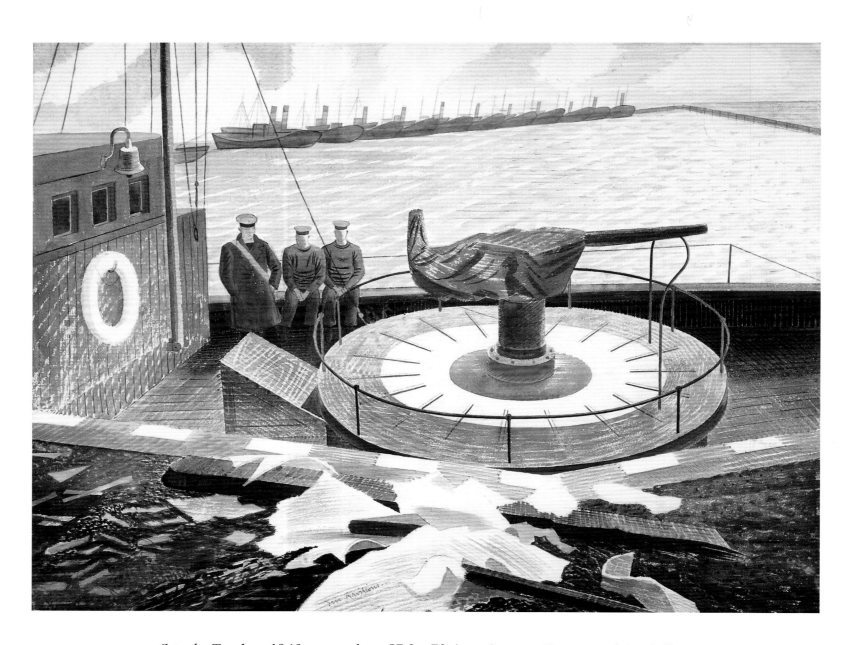

Grimsby Trawlers, 1940, watercolour, 57.2 x 72.4 cm, Potteries Museum and Art Gallery.

INTRODUCTION

In December 1939 Eric Ravilious was invited to become an Official War Artist. He accepted immediately, and went on to produce numerous watercolours (and a fine set of lithographs) addressing a diverse range of subjects, from the *Ark Royal* in action to submariners at work, views from aircraft in flight and even a mobile pigeon loft. In September 1942 he was posted to RAF Kaldadarnes, on the south coast of Iceland, where he and four airmen were lost when their plane disappeared in bad weather. Ravilious was one of only three British War Artists to be killed on active service during World War II, another – by dreadful coincidence – being his friend Tom Hennell.

This book, part of the *Ravilious in Pictures* trilogy, does not attempt to give an exhaustive account of the artist's wartime career, but aims to present a selection of his watercolours and lithographs accompanied by essays that explore the content and context of the pictures, particularly the places and historical moments that he portrayed. Inevitably there are sad stories here, but what emerges most strongly is the luminous, distinctive quality of his wartime work. The same is true of his correspondence, which has been edited by his daughter Anne Ullmann and published by the Fleece Press.

As a student at the Royal College of Art in the 1920s Eric Ravilious was taught by Paul Nash, whose paintings of the Western Front remain such a powerful testimony of the Great War. Although both Paul Nash and his brother John were employed officially as War Artists by 1918, both had served as soldiers in the Artists' Rifles, and John in particular was lucky to survive unscathed. It was to John, a close friend, that

Ravilious turned in August 1939 for advice. Ought he to join the Artists' Rifles? Nash counselled caution.

Others shared the view that the country's leading artists should have wartime employment more suitable than soldiering. Kenneth Clark, the charismatic and influential director of the National Gallery, believed that the state should nurture its best artists by employing them to record the progress of the war, and he got his wish. As the last paintings left the National Gallery for safe storage in Wales, he was appointed chairman of the government's War Artists' Advisory Committee, the body tasked with drawing up 'a list of artists qualified to record the war at home and abroad' – for propaganda purposes, one might add. The WAAC would also advise on the selection of artists on this list for war purposes, and on the arrangements for their employment. Its secretary, and the person the artists would deal with most often, was E. M. O'Rourke Dickey.

Eric Ravilious, meanwhile, had found a way to serve his country. On the day war was declared he joined the Observer Corps and spent the autumn watching for enemy aircraft from the top of Sudbury Hill, above his home in Castle Hedingham. Would he be selected as a War Artist? He was doubtful, perhaps because he had trained in Design, not Fine Art, but recent events were in his favour. He had been well known for years as a designer and commercial artist, and earlier in the summer his reputation had been further enhanced by a critically acclaimed exhibition of mesmerising topographical watercolours at Tooth and Sons. In the event he was one of the first artists appointed.

While his friend Edward Bawden went off with the British Expeditionary Force to France and Paul Nash joined the RAF, Ravilious and John Nash were attached to the Admiralty, commissioned with the rank of Captain in the Royal Marines because, as Eric put it, 'the uniform is less conspicuous on land (it is khaki) and without responsibilities and embarrassments at sea'. Neither man was to find life in the Senior Service easy, however. During his first posting to HMS *Pembroke* in Chatham, Ravilious experienced the Navy at its most formal. In a diary entry of October 1941, John's wife Christine observed:

'Eric amused me by saying that he would like to rush aboard the largest Man of War, saluting madly in all directions, rush up to the highest part of the external plumbing, blow his Marine whistle shouting, "Gentlemen, today I am going to give you a short talk on Renoir – Gentlemen – I give you Renoir!"'

Unusually for the easy-going Ravilious, he seems to have clashed with his first Commander-in-Chief. This wartime description of the artist by author and designer Robert Harling may explain why:

'He wore the uniform with a certain degree of insouciance. His carefree collar and wayward tie would certainly have roused the spleen of any senior officer of that most spick and span of martial outfits.'

There was nothing insouciant, however, in his attitude to work. In civilian life he had persevered in the most terrible weather conditions, and now he worked with equal concentration in the face of enemy fire. So prolific was his output that he was embarrassed by the number of his paintings on show at the National Gallery's first exhibition of war art in July 1940. At first he had to remind himself to focus on suitable subjects, but by the time he flew to Iceland he was painting watercolours that satisfied both his individual artistic needs and those of his employers (and the war effort).

Before the war, Ravilious occasionally expressed his concern that he, like other artists before him, would outlive his talent. Or could he, as he hoped, negotiate middle age and be 'the camel that gets through the Eye of the Needle'? At the time of his death, when he was 39, he was experimenting with new methods to suit new subject-matter, and producing work that was fresh and original. With his sense of wonder and fascination for the unusual undiminished, he left us with a vision of life during wartime which blends defiance with exhilaration and insists that there is a place for beauty in the darkest times.

THE PAINTINGS

Morning sunlight falls across a strange scene. In a roofless shelter improvised from sandbags, duckboards and a canvas windbreak, two men seem to be studying a sextant. With their mismatched hats they look like gentleman-scientists, but these men are in fact the eyes and ears of the RAF, members of the Observer Corps whose role it is to watch the skies and use a device known simply as 'the Instrument' to plot the movement of enemy aircraft. 1500 of these observation posts were established around England in the early months of World War II. This one was built on Sudbury Hill, overlooking the Essex village of Castle Hedingham, by local joiner Bertram Hogarth, and was manned twenty-four hours a day by a team of Observers that included Hogarth himself, Great War veteran Cyril Baines and Eric Ravilious.

Only days before the declaration of war Ravilious had been in Sussex, where his wife Tirzah gave birth to James on 22 August. He had planned to spend part of September sketching chalk hill figures, but instead he was observing aircraft, stealing odd minutes to make drawings like this one, while three boys from Wood Green and their grandmother settled in to life as evacuees at Bank House, the Ravilious family home.

Over the summer Ravilious had been dissuaded by John Nash from joining the Artists' Rifles but remained determined to do his bit, and rumours of an Official War Artist scheme gave hope that he might be able to devote his talents to the war effort. Demand for commercial artwork had in the meantime dried up, leaving the family in financial straits, but Ravilious accepted the situation with equanimity. Before long Tirzah came home with John and James, and the family began to adapt to life in wartime, seizing occasional opportunities for pleasure. In November the local soldiery hosted an oyster party, and they had two dozen apiece with brown ale and bread and butter. Tirzah ordered and ate a whole lobster.

'The following day,' Ravilious wrote, 'we asked the whole searchlight party in to eat two large hares, which they did with ease, and played progressive ping-pong afterwards, round our table. The noise of military boots was like thunder.'

Ravilious took his new job seriously, but wrote about the 'Hedingham Front' with typical humour, describing to Helen Binyon how Observers wore 'lifeboatmen's outfits against the weather and tin hats for show'.

'It is like a Boy's Own Paper story,' he continued, 'what with spies and passwords and all manner of nonsense: all the same as far as wars go it is a congenial job, and the scene lovely, mushrooms about and blackberries coming along and the most spectacular sunrises.'

Observers' Post, 1939, watercolour, 43.4 x 58.4 cm, Cecil Higgins Art Gallery, Bedford.

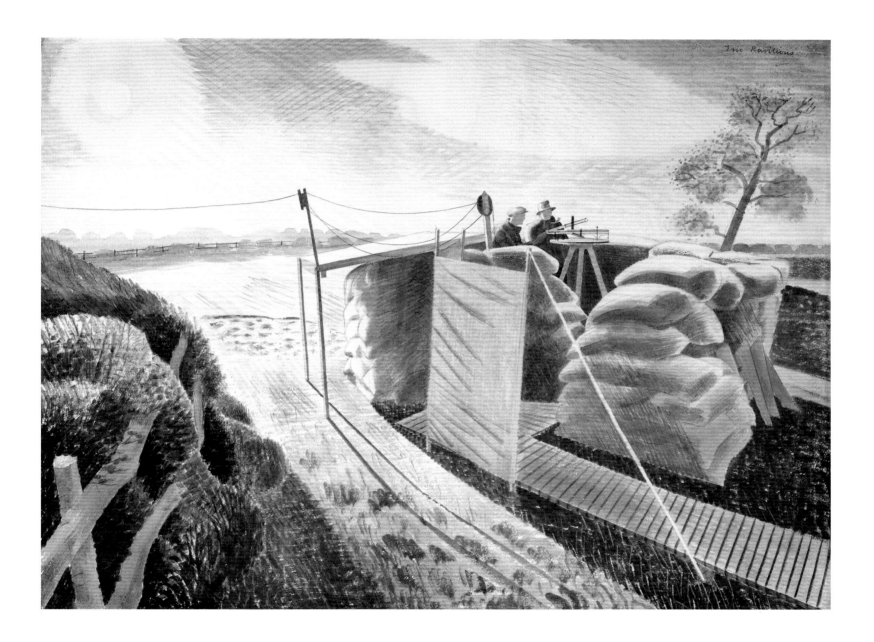

A WARSHIP IN DOCK

On 23 December 1939 Ravilious received an invitation to work for the Admiralty as a War Artist. He accepted with alacrity but then had to endure weeks without further news, likening himself in his frustration to 'Lot's wife, caught on one leg and half turned to salt'. Finally he was commissioned as Captain in the Royal Marines and given his first posting, to the Royal Naval barracks at Chatham in Kent. On 12 February he reached HMS *Pembroke* — as the barracks was known — to find a world rather different from the one he knew.

Though technically a ship, HMS *Pembroke* was in fact a group of buildings, which stood surrounded by the foundries and factories of Chatham Dockyard. Since its dedication by Elizabeth I in 1567, countless ships had been built at the dockyard; Nelson's flagship HMS *Victory* was laid down in 1759 on the site of the dry dock shown here by Ravilious. Although the dockyard closed in 1983, this dock itself can still be seen today as part of the Chatham Dockyard museum, where it is occupied by HMS *Cavalier* — a World War II destroyer similar to this one.

Back in 1940, however, Chatham was a bastion of naval tradition, ruled by Admiral Sir Reginald Aylmer Ranfurly Plunkett-Ernle-Erle-Drax, KCB DSO DL. While Edward Bawden explored France with the British Expeditionary Force, Captain Ravilious did his best to cope with the niceties of naval and mess etiquette, telling Dickey, the secretary of the WAAC, that 'a new recruit has to be on the alert the whole time in order not to make devastating mistakes'.

Surrounded by admirals on all sides, he was constantly brought up sharp to salute and say 'sir', but acquitted himself properly when King George VI came to inspect the dockyard on 21 February. Evenings were spent at the vast and well-stocked mess among his fellow officers, 'all erect blue and handsome and almost all very nice and friendly'. The admirals he described as 'a size larger than lesser ranks and more gold and trappings, also a bit pinker as a rule — they are indulgent about my lapses of naval etiquette'.

Though entertaining enough, this wasn't the seafaring life the artist had looked forward to, and this painting seems to reflect his frustration. Held in position by numerous lines, the ship lies in the flooded dock, though whether recently arrived or about to depart it is impossible to say. Ravilious had often painted ships in harbour, but not like this, looking up towards the bow painted with the jagged teeth of marine camouflage, as if in the path of the oncoming vessel. Both ship and artist are ready for action; both must wait for the order to sail.

A Warship in Dock, 1940, watercolour, 43.1 x 57.7 cm, Imperial War Museum, London.

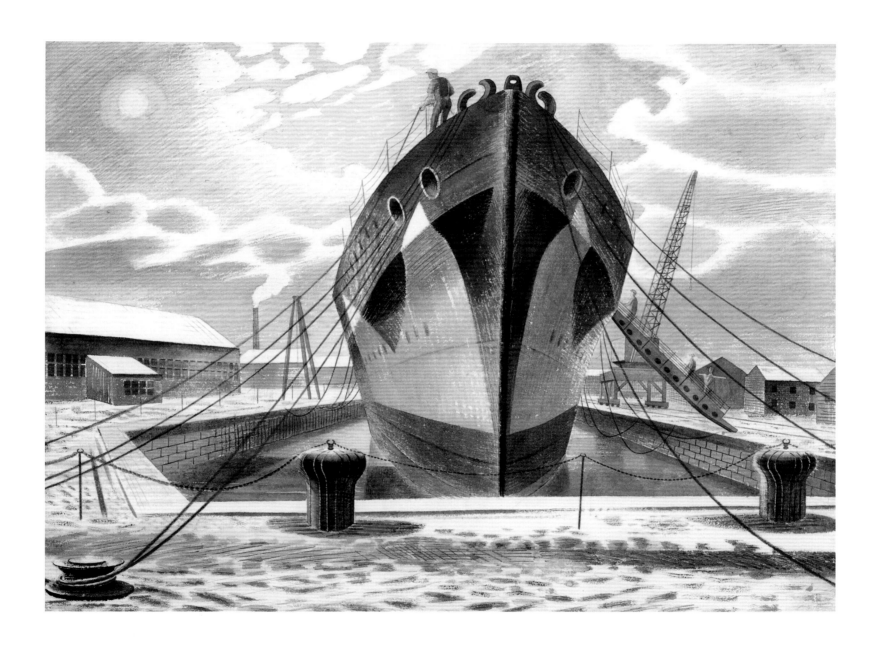

SHIP'S SCREW ON A RAILWAY TRUCK

As he began to adapt to military life, Ravilious faced unforeseen difficulties. Although employed to give an account of the war, his presence was not necessarily welcomed by the soldiers and sailors whose job it was to defend the country. Rather, they looked on the artist with suspicion, obliging him to produce a sheaf of passes at regular intervals, and occasionally accusing him of spying.

'The sentry at the gate plunges a bayonet and barks like a dog,' he wrote in some alarm. 'You might easily forget your name.'

As a civilian Ravilious had always gone where he pleased, and as a painter had chosen his own subjects. Now he found his work constantly interrupted, while the subjects that inspired him were not always those his employers wanted him to paint. His request to sketch an admiral's bicycle was refused, and he resisted the temptation to set up his easel before a splendid statue of a 19th-century Royal Marine. Searching for inspiration in Chatham Dockyard he discovered this propeller loaded onto a railway truck, which was both a suitable subject and the kind of quirky wheeled conveyance he loved to paint. Indeed, he might have picked out the ship's screw at any point in his career, but here, surrounded by the dark and desolate wastes of the frozen dockyard, it glows like a sacred artefact, its curved surfaces mirroring the swooping lines of tracks in the snow.

Ravilious was soon to escape the dockyard, but remained under the command of Admiral Drax, who admired neither his art nor his rather insouciant attitude to matters of dress. Their less than cordial relationship came to an abrupt end in August, when Ravilious was summoned back to Chatham for a dressing-down. The Commander-in-Chief, he reported, 'read a lecture from his grand mahogany desk with the assurance of the Pope'. Ravilious did his best to respond, but was not unhappy to be replaced by Charles Cundall, a Great War veteran and creator of epic naval paintings. Cundall proved much more to the Admiral's taste, but in this painting we see Ravilious applying himself to the subject of war and producing work as hauntingly beautiful as his pre-war watercolours.

It is a valuable record too, recalling the bitterly cold winter of 1939–40 and the period known as the Phoney War. While the general population waited for Nazi Germany to attack France, British mariners fought a desperate war against enemy battleships and U-boats to keep vital supply lines open. The country's survival depended now, more than ever, on winning the war at sea, and in this context Ravilious's vision is at once purposeful and optimistic: the propeller that will drive the ship that will win the war.

Ship's Screw on a Railway Truck, 1940, watercolour, 42.5 x 53.3 cm, Ashmolean Museum, Oxford.

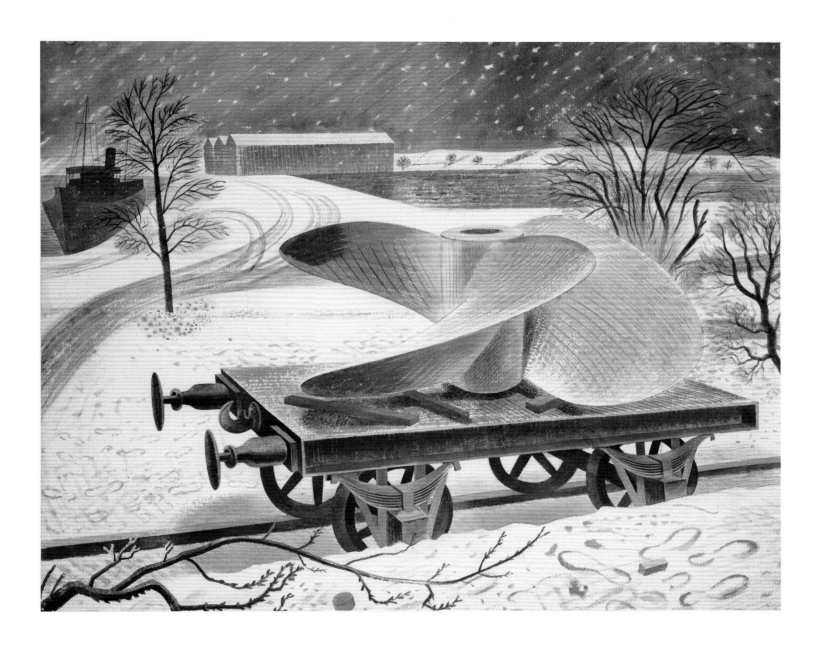

DANGEROUS WORK AT LOW TIDE

After three weeks at HMS *Pembroke* Ravilious was offered a chance to escape, and his relief is evident in this luminous painting. The scene is Whitstable Sands, where a German magnetic mine had been found on the oyster beds. Sown by aircraft in shallow waters, magnetic mines were designed to explode when the iron hull of a ship passed overhead, and in the first months of the war they proved devastating. This was only the second such mine discovered intact, and Ravilious was invited to travel with a group sent to render it safe. 'After Chatham it was like being let out of school,' he wrote. 'This was the best sort of outing, packed with excitement…'

The painting too is full of interest. In the middle distance three figures walk purposefully towards an unseen goal, while a larger group of men wait in the foreground. The long oars, barrels and other equipment heighten the sense that these men are specialists engaged in dangerous work.

Ravilious was taken to Whitstable by Commander Edward Obbard and Lieutenant Harold West, described by him as 'two of the nicest people I met at Chatham'. The other player in this drama – the third purposeful figure – was Lieutenant Commander G. A. Hodges, a mine disposal expert – with four months' experience, he had four months more than most – sent from HMS *Vernon* in Portsmouth when the mine was first discovered in January 1940.

Driving through snow to Whitstable, Hodges arrived at night and immediately waded out into water that was covered in a layer of slushy ice. Having located the half-submerged bomb he removed the fuse, but was too cold to continue and had to return twice more. It was on the third occasion that Ravilious went along as observer. In his autobiography *Of Mines and Men,* Hodges describes how the party made ready on the shore at 6 a.m. on the second day.

'The moon was still up, a glorious sunrise followed, and the wind was set offshore. I reached the mine, and without difficulty removed the primer and fitted the towing spindle and the lifting clamp. The mine was now safe from detonation… The seamen secured the flotation casks, and fixed the whole to a stout stake which was firmly driven into the oyster beds. We then retreated before the advancing tide and went to breakfast.'

On their return they discovered that the lines had broken and the casks dispersed around the bay, so the exercise was repeated the following day. The mine was successfully recovered and taken to Chatham. Three months later Ravilious delightedly reported that Commander Obbard and Lieutenant West had been awarded the Distinguished Service Cross for their work.

Dangerous Work at Low Tide, 1940, watercolour, 43.2 x 53.5 cm, Ministry of Defence Art Collection.

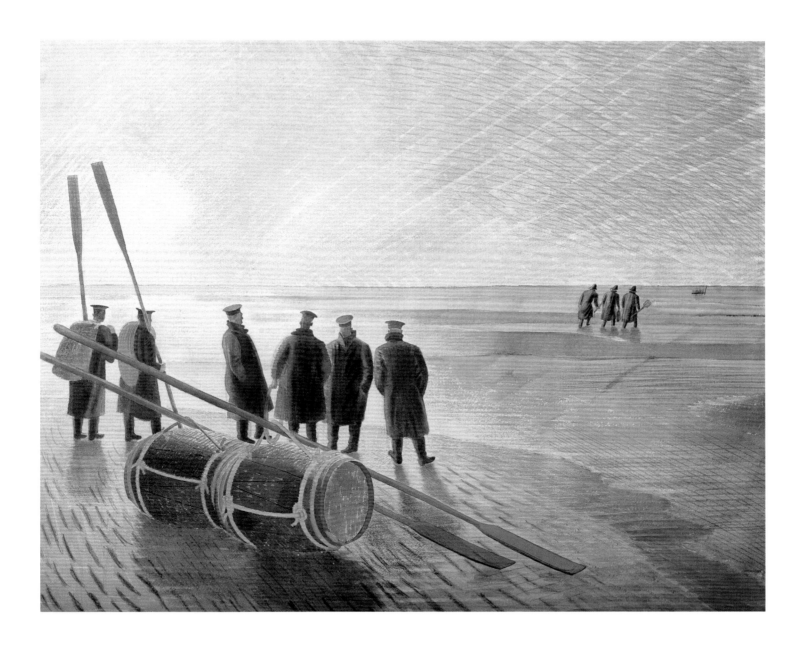

A fishing boat rides the swell outside an English port, towing a barrage balloon. In the stiff breeze the balloon tugs at its cable, making the bow of the boat lift; with the choppy sea and the figures braced against the wind on the quayside the painting seems alive with energy and motion.

Ravilious's eye for the unusual found an ideal subject in the curved quay and pillared porticos of Sheerness – a blustery Venice in miniature. The distinctive Regency buildings had housed HMS *Wildfire*, a naval gunnery school, until it was transferred to Chatham in the 1930s, but the port was also a popular holiday town. Arriving from Whitstable Sands, Ravilious stayed at the venerable Royal Fountain Hotel and explored his surroundings with interest and pleasure.

He had admired barrage balloons since his days as an Observer, when the lolloping giants seemed continually to be escaping. One 'trailed its rope over the country, fusing lights for miles around', while another drifted high above the castle at Hedingham early one morning, gleaming 'like a threepenny bit'. These escapees were either shot down or – more romantically – allowed to float away to Sweden.

In his fascination with the balloons Ravilious reflected their real importance in the defence of Britain. First deployed in 1917 against the Gotha bombers that threatened London, they were being manufactured in large numbers as World War II loomed. By August 1940 around 1400 balloons protected ports and other key installations from attack. Though ungainly and disaster-prone they deterred enemy aircraft from diving on targets, so preventing the Luftwaffe from carrying out the low-level bombing that was such a terrifying part of Blitzkrieg. The balloons shown in the distance are protecting the Thames Estuary from aircraft sowing magnetic mines like the one rendered safe in the previous painting.

These balloons were raised and lowered by winch, and when Ravilious submitted 'Barrage Balloons at Sea', the painting shown on the cover of this book, to the WAAC, Dickey suggested it be called 'Barrage Balloons being hauled down at sea'. Unfortunately, Ravilious told him, this would not be strictly true, as the right-hand balloon had actually fallen in the 'drink', and was being hauled out.

With his background as a commercial artist, Ravilious well understood the propaganda value of his work. In the picture opposite he presents the world with a whimsical portscape – the natural heir to his peacetime portrayals of Bristol, Newhaven and Dieppe – which was also, in the spring of 1940, an important image of a peace-loving country defending itself against the Nazi war machine. There are no guns in this picture, only fishing boats defying Hitler with giant balloons.

Barrage Balloons outside a British Port, 1940, watercolour, 43.8 x 54.0 cm, Leeds Museums and Galleries (City Art Gallery).

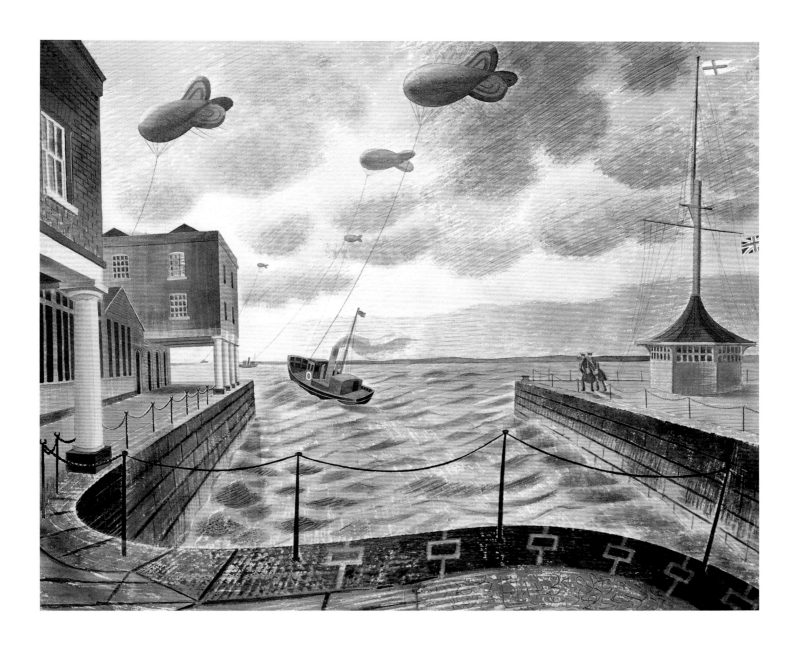

NORWAY, 1940

On 24 May 1940 Ravilious finally went to sea, sailing from Scapa Flow aboard the destroyer HMS *Highlander*. He had been scheduled to sail from Grimsby a month earlier, and when that plan fell through he was invited aboard *Highlander* by Lieutenant Richard Rycroft, a neighbour from Castle Hedingham. The destroyer was escorting the aircraft carrier HMS *Glorious* as part of an expeditionary force sent to recapture Narvik from German troops who had seized the strategically important Norwegian port in April. Ravilious was immediately inspired, recording the fleet's departure in the painting 'Leaving Scapa Flow'.

'This ship,' he told Tirzah soon after his arrival on board, 'is so clean and swept and painted, like a new pin… there are even flowers on the table and chintz curtains. It made me laugh to see a fine cottage chintz in the Wardroom of a destroyer.' And after voyaging into the Arctic: 'I love this ship and feel completely at home: work goes with a swing.'

If only women were allowed on board, his happiness would be complete. Ravilious suggested this to his fellow officers, but they did not share his enthusiasm.

When the task force reached Norway a combined British, French and Polish force took Narvik with comparative ease, giving Ravilious the opportunity to set foot in the far north for the first time and paint this haunting scene. A lifelong admirer of the 18th-century watercolourist Francis Towne, and in particular of Towne's alpine paintings, Ravilious had been planning a trip to Greenland before the war, and now seized his opportunity to paint the Arctic landscape. During the previous weeks a dozen ships – Norwegian, German and British – had been sunk off Narvik, and the dark silhouette of a stricken ship recalls the violence and dead men.

Yet what strikes one particularly about this painting is the light, and it was the light of the Arctic at midsummer that kept Ravilious on deck for hours past midnight.

'The seas in the Arctic Circle are the finest blue you can imagine,' he wrote on his return to Scapa Flow, 'an intense cerulean and sometimes almost black: but of course no icebergs.'

And to Diana Tuely, 'It has been a wonderful trip with excitements here and there from planes and submarines, but the grand thing was going up into the Arctic Circle with a brilliant sun shining all night… I simply loved it…'

In the reference to 'excitements' Ravilious makes light of the dangers he faced on the voyage, although he was evidently aware of them, having made a will on May 12. Throughout his career he had shown himself impervious to discomfort when inspired by a particular scene, and aboard HMS *Highlander* he discovered that enemy action was no more of a distraction than a biting wind.

Norway, 1940, watercolour, 45.1 x 55.9 cm, Laing Art Gallery, Newcastle upon Tyne.

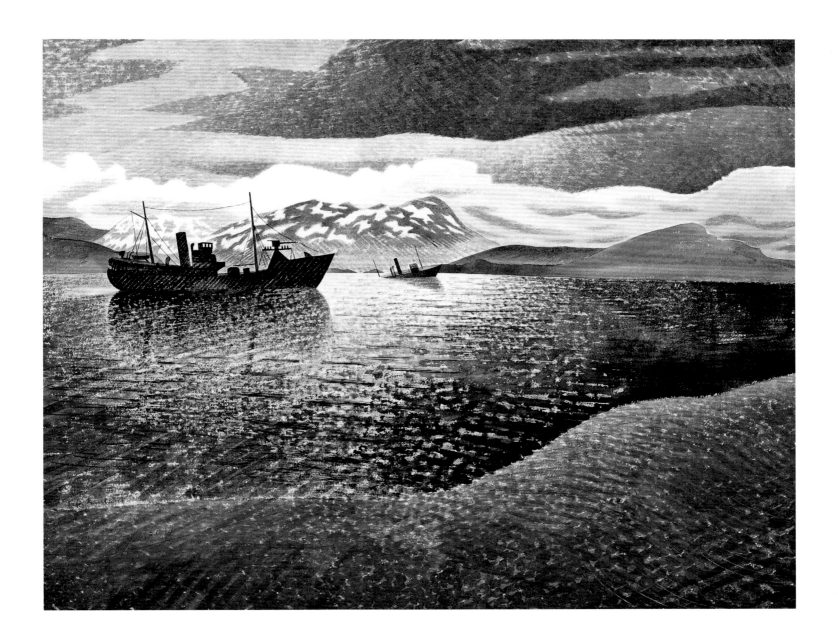

HMS GLORIOUS IN THE ARCTIC

Brightly lit by the midnight sun, aeroplanes swoop and soar around the aircraft carrier HMS *Glorious,* circling like Arctic terns against the incandescent sky. But if the treatment of the aircraft is playful, the jagged white light that cuts across the surface of the water adds urgency to the painting, reminding us that the ship is camouflaged for a purpose.

Ravilious left Scapa Flow for the second time on 31 May, as HMS *Highlander* again escorted HMS *Glorious* to Norway. The German invasion of France had rendered the Norwegian campaign irrelevant and on 4 June a general evacuation of Allied forces began. On the night of 7/8 June a squadron of Hawker Hurricanes flew from their Norwegian base to *Glorious,* where all eight planes landed successfully – the first time this particular model had achieved such a feat. This painting shows the Hurricanes – and the Gloster Gladiators whose pilots had shown such bravery during the campaign – circling the carrier as they prepare to land, completing a daring escape.

Then, in the early hours of 8 June, Captain Guy D'Oyly-Hughes, commander of HMS *Glorious,* was granted permission – under circumstances that remain mysterious – to leave the convoy and go on ahead to Scapa Flow. This time HMS *Highlander* stayed behind with the carrier *Ark Royal,* while the destroyers HMS *Acasta* and HMS *Ardent* accompanied *Glorious.* That evening the German cruisers *Gneisenau* and *Scharnhorst* sighted the three ships, and a direct hit from *Scharnhorst* immediately put the carrier's flight deck out of action. With no protection from the air the British ships were outgunned and, after a furious bombardment, all three were sunk, with the eventual loss of 1,519 men.

'We have been very lucky,' wrote Ravilious to Tirzah on 10 June, while still at sea.

Such was the scale of the disaster that Neville Chamberlain was forced to resign, and Winston Churchill became Prime Minister. Nazi propagandists lost no time in releasing an eyewitness account that described the carrier's last moments: 'Slowly the giant began to turn on her side. Pouring out flames and smoke she drifted with the wind. A moment later she sank.'

A month later the first exhibition of war art opened at the National Gallery, with this painting among a considerable number of works by Ravilious. A critic in *The Times* suggested that the artist was overly preoccupied with capturing the effects of light in Norway, the implication being perhaps that he had failed to convey the full drama of the situation. Others, notably Kenneth Clark, greatly admired the Norwegian watercolours, and today this luminous painting serves as a fitting memorial to HMS *Glorious* and the men who died with her.

HMS Glorious in the Arctic, 1940, watercolour, 45.1 x 56.8 cm, Imperial War Museum, London.

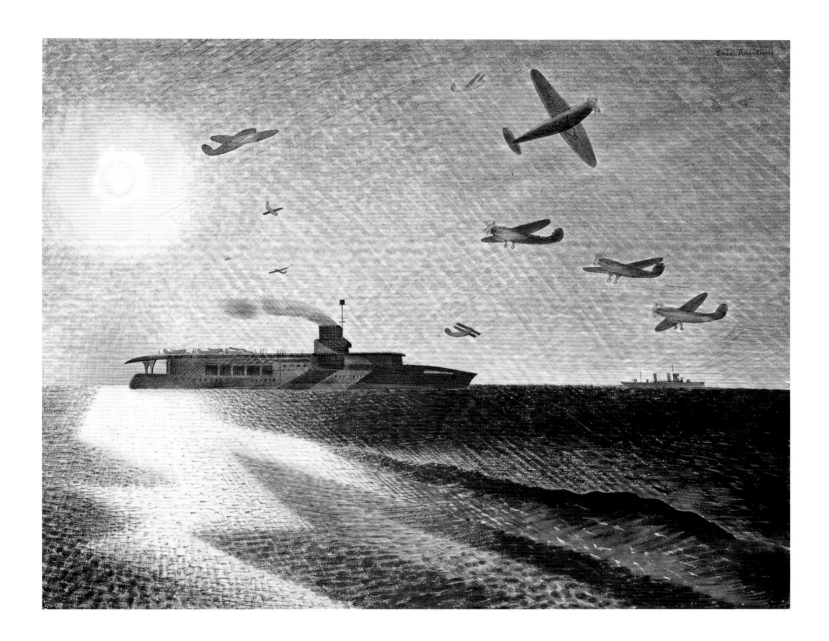

HMS ARK ROYAL IN ACTION

The Battle of Britain and the Blitz so dominate the mythology of World War II that we risk forgetting the vital part played by the Royal Navy. From day one British sailors were engaged in a desperate battle to keep open the lines of communication between their island nation and the Empire it had come to rely upon for food and raw materials. For centuries the Navy's 'wooden walls' had defended Britain and in 1940 Hitler was as wary of the fleet as Napoleon had been.

This painting of HMS *Ark Royal* in action would have made sense to a visitor from the Napoleonic age, or even the days of the Armada, when the first *Ark Royal,* a galleon originally built for Sir Walter Raleigh and named *Ark Raleigh,* fired broadsides at the Spanish invasion force of 1588. The name was not used again until 1914, when it was given to a merchant ship converted for use as an aircraft carrier; she was subsequently renamed so that a new ship, launched in 1937, could in turn become HMS *Ark Royal.* This fast new carrier went into action as soon as the war began, narrowly escaping a U-boat attack on 14 September 1939, and was recalled from the Mediterranean, along with HMS *Glorious,* to provide air cover for the occupation of Narvik and subsequent evacuation.

From the deck of HMS *Highlander* Ravilious made two paintings of the carrier in action, firing the anti-aircraft guns positioned just below her flight deck. In descriptions of his Norwegian voyage he likened exploding bombs to fireworks, and here the gunflashes resemble a display – an expression of defiance, perhaps, on the part of the retreating force. Dated (with unusual precision) June 9, the painting shows the final moments of the Allied withdrawal from Narvik.

The carrier did not return to Scapa Flow immediately but instead set out to revenge the loss of *Glorious,* steaming south in pursuit of the German cruiser *Scharnhorst.* A flight of Skua bombers was dispatched to attack the battleship in Trondheim harbour, but without success. During the voyage Ravilious painted the aircraft carrier once more, dwarfed by the ocean and the fiery midsummer sun. In the foreground of 'Midnight Sun', a depth charge and a lifebelt recall the dangers lurking beneath the sea and beyond the horizon, but *Ark Royal* and her escorts returned safely to Scotland. The carrier went on to achieve lasting fame in the sinking of the *Bismarck* and continued to live up to her reputation as a lucky ship until November 1941, when she was struck by a torpedo off Gibraltar and sunk. Even then, 1500 sailors were saved.

HMS Ark Royal in Action, 1940, watercolour, 42.5 x 57.7 cm, Imperial War Museum, London.

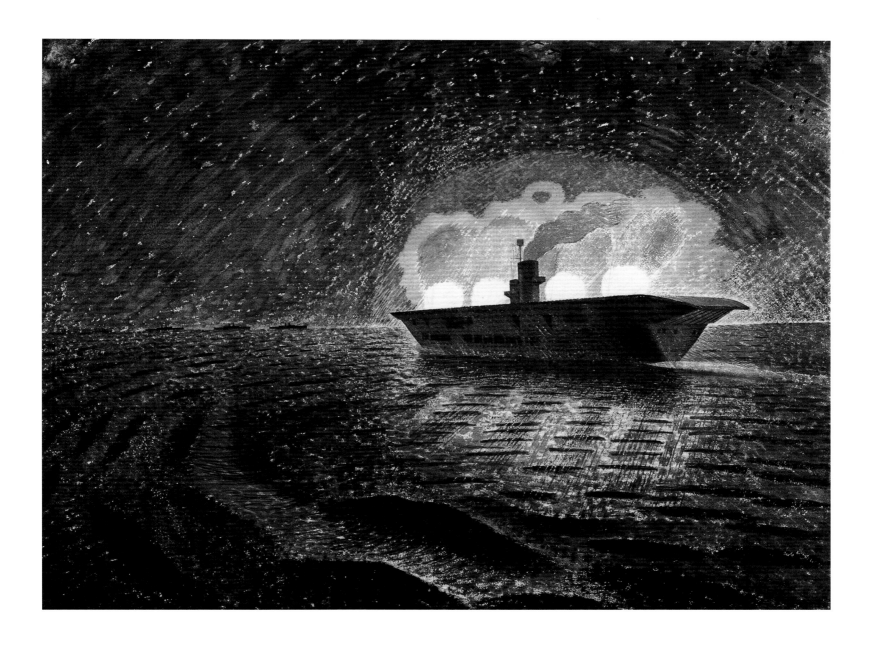

WARD ROOM NO. 1

On his return from Norway Ravilious was posted to Portsmouth, where the man in charge was Admiral Sir William 'Bubbles' James, a nephew of Millais and his model for the whimsical painting used to advertise Pears soap. Admiral James was a tremendous character; he was 'like a figurehead', Ravilious thought, 'and would make a fine one'. The pair hit it off, but the artist approached the vast naval base with trepidation, likening himself to 'an earwig setting out to draw Buckingham Palace'.

Then an inspired move across the water to Gosport took him to HMS *Dolphin,* a training base for submariners, and for the next two weeks he sailed every day, enjoying the easy motion of the submarine through the water compared to the pitch and roll of a destroyer in the North Sea.

He had tried naval interiors before. The bridge of a destroyer had intrigued him with its 'mass of speaking tubes like some sort of sprouting African lily', and so had the flowers on the wardroom table aboard HMS *Highlander,* but this was something altogether different, more like the interior of a machine with 'the complexity of a Swiss clock'. True to form he was undeterred by heat or noise, and for an artist who loved the airy Sussex Downs he was surprisingly unaffected by claustrophobia.

'There is hardly room to move, of course,' he wrote, 'so drawings have to be hasty. There is something awfully good about them if only I can manage it: a blue gloom with coloured lights and everyone in shirts and braces. People go to sleep in odd positions across tables.'

Working from life and from photographs, Ravilious laboured over a dozen drawings. From these he planned to make a series of lithographs, a scheme he approached with enthusiasm that was understandable given the success of *High Street,* his pre-war book of shops. The WAAC, however, was reluctant to fund the project and Ravilious spent the last months of 1940 trying to find a publisher for a children's painting book based around the lithographs. In December he gave up and set about producing lithographs himself out of his own pocket. With the Curwen Press damaged by bombing he went in search of a new printer and found W. S. Cowell of Ipswich, 'actually Geoffrey Smith', whom he described as 'nice and a socialist', and by March 1941 the proofs of ten lithographs were ready. Of these, one was censored, while the rest went on sale at the Leicester Gallery in London. The WAAC opted to buy the original drawings which, like the lithographs, convey both the strange interior space of the submarine and the unreal conditions of the submariner's life in an idiosyncratic, compelling way.

Ward Room No. 1, 1940–1, lithograph, 28.0 x 32.0 cm, Fine Art Society, London.

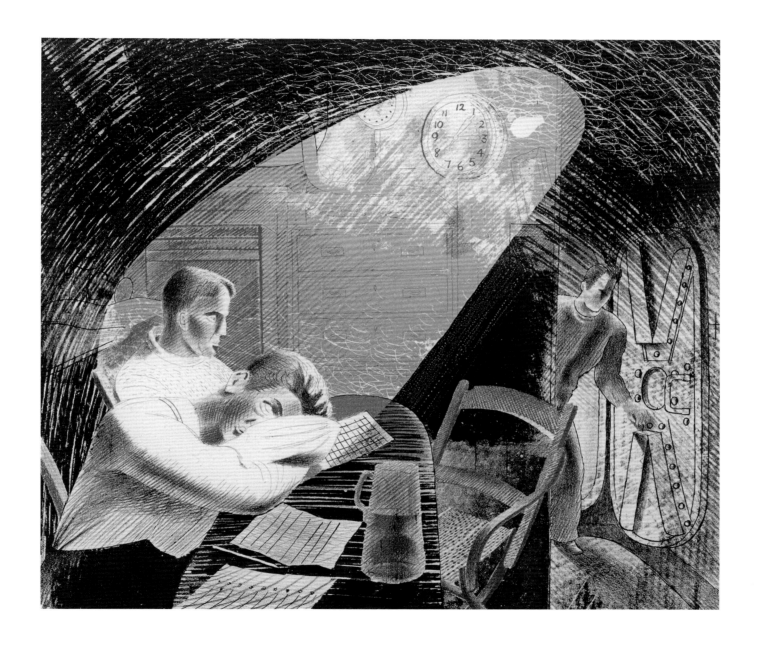

COASTAL DEFENCES NO. 2

As dark clouds billow overhead, men line the ramparts of a clifftop fortress, staring out to sea. A 6-inch gun, draped in camouflage netting, points in the same direction. Since the days of the Vikings, men had watched the sea from English clifftops, scanning the horizon for the dark shapes of hostile ships, and in September 1940 the threat of invasion was real and immediate. The men shown here know that Hitler plans to take Newhaven, and are prepared for close combat. Their fort, built in 1862, is protected by cliffs, barbed wire, stone walls and earth ramparts, its massive bulk balanced here by the birds swooping across the cliff face below. The Red Ensign reminds us that this is a naval installation.

Ravilious travelled to Newhaven – a port he had often visited in the 1930s – at the suggestion of Admiral James, who recommended he draw coastal defences. After experiencing one of the first nights of the London Blitz, which he described as 'awful, romantic and nightmarish', he arrived in Eastbourne on 18 September to find his hometown smashed and empty, 'like the ruins of Pompeii'. 60,000 people had left town, including Tirzah's family and his own. Bombs had fallen on the art school and the maternity home where James was born the previous August, and the pier lay broken in two. To Ravilious it seemed like a bad dream.

Newhaven was, by contrast, 'solid and naval and reassuring'. The port's proximity to France had made it the main departure point for men and munitions during the Great War, and on the outbreak of World War II the ferry terminal with its connection to the rail network became a casualty clearing station for the British Expeditionary Force. However, the same qualities made the port a prime target in Hitler's invasion plan, and although heavily defended, with the only battery of 6-inch guns between Dover and Portsmouth, it was regularly threatened by enemy aircraft. On arrival Ravilious was issued with a service revolver and a tin hat – the former a dead weight to haul around, while the latter, he noted, 'seems to cram my neck into my coat like a tortoise' – but in the circumstances he accepted the discomfort.

'I'm all for the tin hats,' he wrote, 'with Germans just overhead as I work. They fly as they like.'

So perhaps there is an element of propaganda in the reassuring images Ravilious dubbed his 'pre-invasion drawings', although he himself seemed unperturbed by the threat from above, remarking dryly that German bombers only came over at teatime 'and hit ecclesiastical objectives and allotments'. Having had no reason to paint the fort in peacetime he now did so repeatedly, leaving us with an engaging record of Britain's darkest hour.

Coastal Defences No. 2, 1940, watercolour, 46.4 x 59.0 cm, Museum of New Zealand, Te Papa Tongarewa.

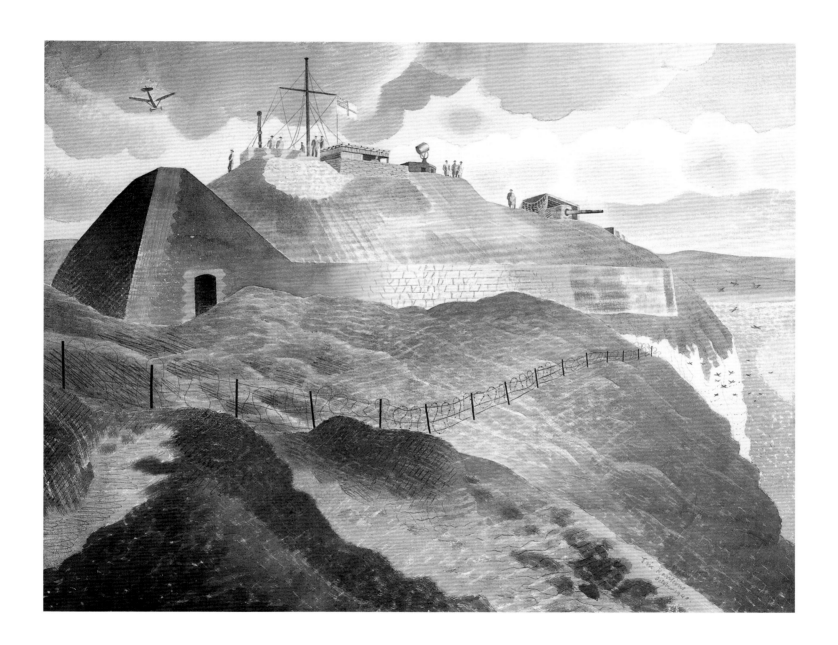

COASTAL DEFENCES

In 1939 Ravilious painted a striking watercolour of the Beachy Head lighthouse at night, and this painting has a similarly watchful atmosphere. But whereas the lighthouse warns mariners of deadly rocks, the searchlight shown here is defending the land. A division of the German 9th Army would have come ashore in Seaford Bay, curving away in this picture towards the chalk cliffs of Seaford Head, had Hitler launched Operation Sealion, and enemy planes were a constant threat.

Newhaven bristled with barbed wire and concrete anti-tank cubes. Here one can make out, to the right of the breakwater, the disturbance in the water caused by iron girders driven into the seabed to repel invasion barges, but most striking is the flotilla of motor torpedo boats (MTBs) heading out to sea. Against the soft night colours, the sharp dark silhouette and hard white wake of one boat, then the next, suggests the stark purpose of a Morse Code message. This is defence at its most aggressive.

Stationed at HMS *Forward*, the naval base in Newhaven, these 70-foot motorboats were instrumental in the defence of the south coast, patrolling inshore waters and harassing enemy shipping. MTBs were built in large numbers by Vosper Ltd, of Portsmouth, and took part in the evacuation of Dunkirk, the ill-fated 1942 Dieppe Raid – which was launched from Newhaven –

and the D-Day landings. A few survive today as unusual and rather menacing houseboats. During his time in Portsmouth Ravilious had enjoyed a fast ride in an MTB along the coast of the Isle of Wight, noting the roar of the engine and the wake 'like a fountain behind'.

'They go like the wind,' he wrote, 'and wet you to the skin.'

There could be no such excursions here on the front line of Britain's defence. Instead Ravilious carried his equipment, tin hat and revolver up to the fort twice a day, like a man going to the office. As his stay in Newhaven stretched into October, he was unsure what his next move would be. His original contract as a War Artist had finished and, while the WAAC wanted him to carry on, the Treasury showed no inclination to pay him.

'I've suggested a trip to Iceland later,' he wrote to Helen Binyon, 'to draw the Royal Marines in hibernas, with Duffel coats and perhaps those splendid plum skies.'

In the meantime he took advantage of an appointment with a chiropodist in Brighton to indulge in one of his favourite pastimes – junking. He found a marbled mug for Tirzah and wondered whether to buy a floor lion for James. And, he told Tirzah, 'I bought a Waterloo commemorative picture which really is a corker.'

Coastal Defences, 1940, watercolour, 45.7 x 61.0 cm, Imperial War Museum, London.

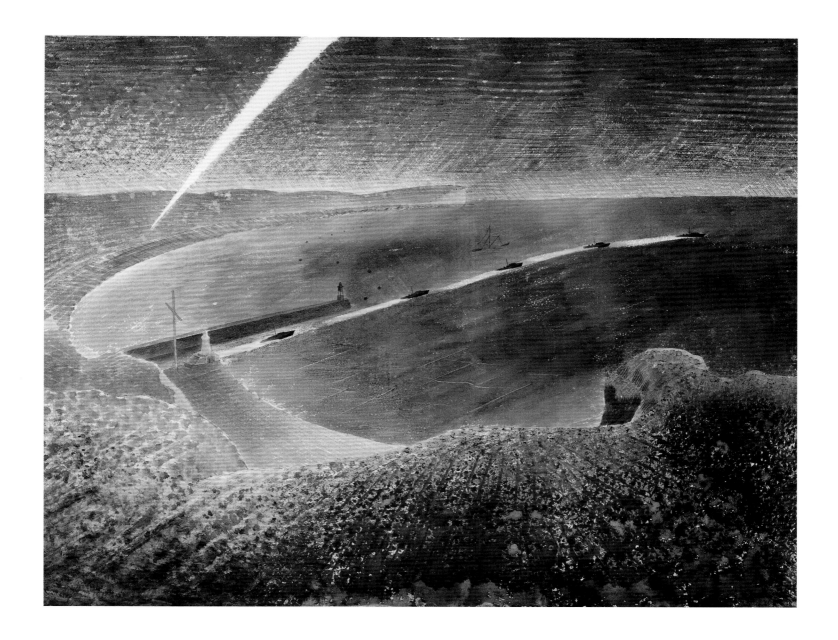

By 1941 the great paintings of the National Gallery lay hidden in a Welsh quarry, while beneath the streets of London a subterranean labyrinth protected vital government departments from aerial bombardment. Above ground the destruction was unimaginable, one victim being Morley College and the murals painted there by Ravilious and Bawden in the late 1920s. Here Ravilious gives us a glimpse of civilisation driven underground – a vision to complement Henry Moore's tube station sleepers.

In January 1941 Commander Aylmer Firebrace, the aptly-named leader of the London Fire Brigade, became Chief of Fire Staff and oversaw the construction of the Home Security Control Room beneath Whitehall. When the new headquarters became operational, just after the publication of Ravilious's submarine interiors, the artist was invited to record his impressions. In a series of paintings including 'The Teleprinter Room' and 'Room 29, Home Security Control Room' he captured the extraordinary atmosphere of this underground world. Whereas the submarine interiors are hot, bright and intensely focused, this passage is cool and sinister, filled with harsh electric light and occupied by unsettling objects and figures, from the library stepladder and mysterious filing cabinets to the man in the doorway who resembles a character in a Cold War thriller.

The artist's pre-war paintings often hint at a hidden meaning, and here the effect is magnified. The map on the right, divided into numbered sectors and studded with dark points, demands interpretation, but the sign suspended from the ceiling only confuses matters. One can make out 'MAJOR', but the second word seems to have been erased. The date on the painting too is strange, reading May 1940 when we know this corridor did not exist until 1941. Why would Ravilious put a false date on a painting?

The answer lies in the artist's relationship with the military censors. Over the previous year he had seen some fine work condemned to see out the war in a vault, and one of the submarine lithographs was censored even though the original drawings had all been passed. Artists could never predict what the censor might take exception to, and here Ravilious has taken careful precautions. The map is left deliberately vague, so that it is impossible to be sure that it represents London, while the word 'DAMAGES' after 'MAJOR' on the sign has been cast into shadow.

In June Commander Firebrace wrote to Ravilious, expressing his enthusiasm for the paintings and hoping that they would escape censorship – 'it would be ridiculous'. However, the continuing danger of invasion made the control room a sensitive subject, and today the back of this painting bears a censor's stamp, dated 18.6.41, and the words 'Not to be exhibited during the war period'.

No. 1 Map Corridor, dated May 1940, watercolour, 38.9 x 57.4 cm, Leeds Museums and Galleries (City Art Gallery).

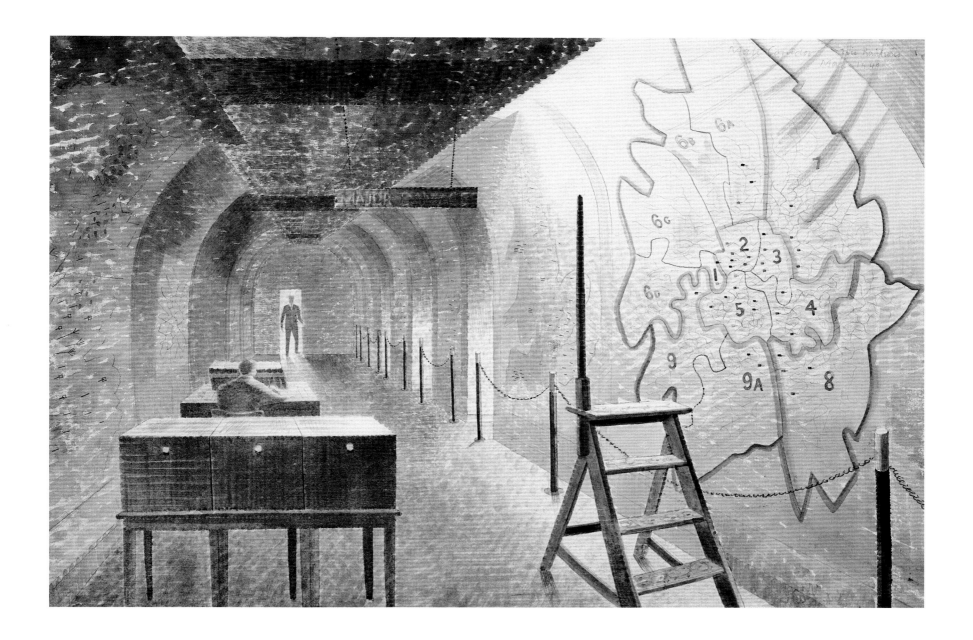

BOMBING THE CHANNEL PORTS

Only 22 miles from the French coast and subject to constant shelling from heavy artillery, Dover had become known as Hellfire Corner by the time Ravilious was sent there in August 1941. Signed up for another six months with the Admiralty, which controlled the port and its defences, he travelled south-east to find a town more ruined and desolate even than Eastbourne.

In his pre-war career, Ravilious had often chosen to portray man-made objects in the landscape, from fences and wind pumps to abandoned machinery and factories. Here, as in Newhaven, he shows the landscape of coastal defence, with its roads and telegraph posts, coils of barbed wire and, in the middle distance, a slab of concrete that seems to be blocking a route up from the beach. It is late evening or dawn, and in the distance, across the water, searchlights probe the sky. As the title suggests, Allied bombers are at work over the French coast.

Strategically positioned on the cliffs above Dover were a pair of massive 14-inch naval guns, nicknamed Winnie and Pooh, which duelled for years with the German artillery in the Pas-de-Calais as each side sought to dominate the English Channel. These and other batteries were manned by soldiers of the Royal Artillery, who went out of their way to help the artist; they even offered to send a runner to wake him if anything spectacular should happen during the night.

'I feel a stir in me that it is possible to really like drawing war activities,' he wrote to Diana Tuely.

There was less naval pomp and formality in this frontline port than elsewhere. Indeed, the town resembled a battlefield, with bandstands turned into gun emplacements and streets of empty, half-ruined houses. Ravilious considered sketching these wallpapery interiors but couldn't bring himself to emulate John Piper, whose paintings of bombed buildings proved so popular with public and critics alike. Instead, Ravilious found inspiration on the beaches, which were fuller than ever of curious flotsam, such as the skeleton of a horse, a parachute and a lobster pot with three crabs inside, not to mention a rowing boat that had somehow arrived from Guernsey, red and banana yellow. He painted it surrounded by barbed wire and iron fencing, with shelling at sea in the background.

He wrote excitedly about these wonders, adding, 'Last year my landlord found a draper's roll there of black pinstripe suiting which he wears on Sundays now.'

Military action proved harder to capture, being often a fleeting spectacle that was over before he could start drawing. Here, though, he succeeds, the fireworks on the horizon offering blitzed Britons a glimpse of the fightback to come.

Bombing the Channel Ports, 1940, watercolour, 38.7 x 48.8 cm, Imperial War Museum, London.

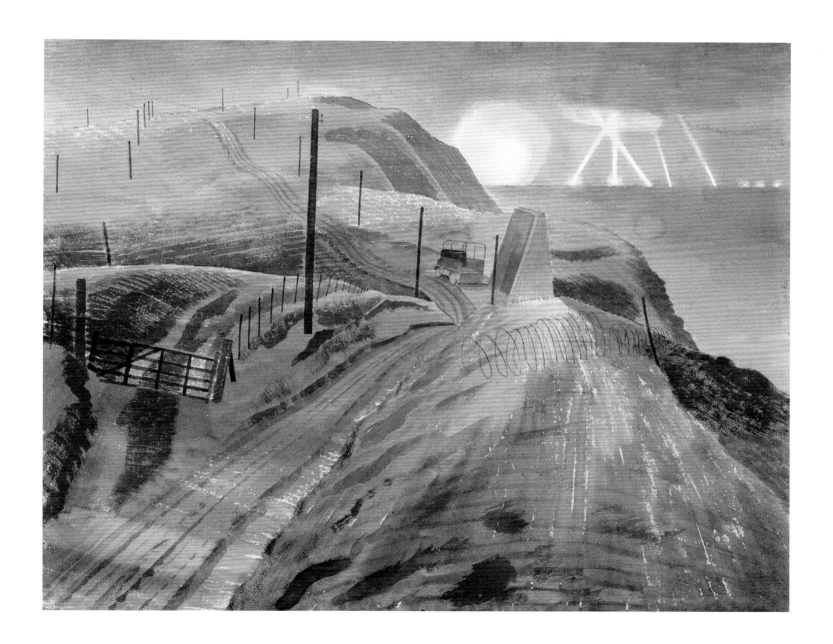

CONVOY PASSING AN ISLAND

October 1941 saw Ravilious heading north to stay with John and Christine Nash at their cottage overlooking the Firth of Forth. John had abandoned his role of War Artist for a job in naval intelligence, based in Rosyth, and he helped Ravilious cut through the red tape that made every movement so difficult; by day Ravilious endured gales and thunderstorms to paint ships, and in the evenings the pair swapped horror stories of life in the Senior Service.

Christine Nash found Ravilious alarmingly thin but soon realised that he was just hungry, and with regular meals of home-cooked food he soon rallied. In her diary she recorded rare impressions of her guest at work in her bedroom, which she had given up for use as a studio. From a room below she listened to the 'pat-pat-pat of texture being laid on, or being taken off by some cunning gadget or other', then his door would open and he would step lightly across the landing to the bathroom, painting in hand. The sound of running water signalled further artistic trickery in progress.

With John's help, Ravilious secured permission to visit the Isle of May, in the mouth of the Firth of Forth – a bird sanctuary in peacetime and now the site of a Royal Navy signal station. Wearing a leather coat against the bitter cold, and the thickest pants he could find in Greenoch, he set out to explore this wild outcrop.

'There are such lovely things on this island,' he wrote to Tirzah, 'huts and lighthouses and wrecks... Hoody crows and golden-crested wrens are about, oh and blackbirds, but the lobster fishing seems to be over... I wish you could see the island. You would love it. There is the oldest beacon – 1636 – in the centre...'

The island, he continued later, 'rolls in great folds for about a mile and a half with a tumble down monastery on the leeward side and the monks have built an enormous cross in walls for their sheep...'

He sketched this for Tirzah, adding, 'not, alas, a war subject and not naval either'. He did, however, manage to work it into a painting that conveys both the wildness of wind and sea and the security of stout stone walls. The aforementioned cross lies beyond the buildings with their distinctive stonework, while the beacon stands above them to the right. A particularly nice touch is the horse at the bottom of the lane, which is dwarfed by the fish barrels in the foreground. Despite the wind and bitter cold, Ravilious succeeded in painting not only a convoy passing an island but also the island itself, layer on layer, in loving detail.

Convoy Passing an Island, 1941, watercolour, 49.5 x 54.0 cm, The British Council, London.

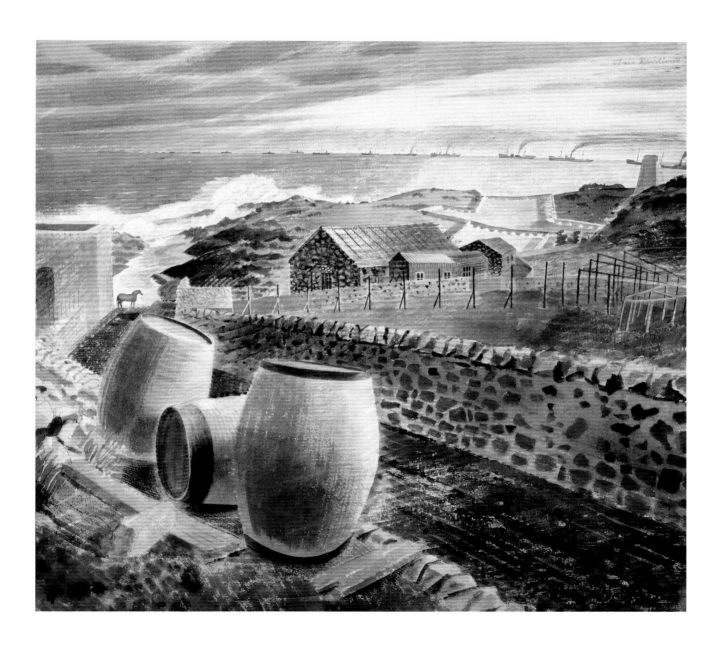

MORNING ON THE TARMAC

Between a pale yellow sun and its watery reflection a group of airmen wait beside their planes for some sign or signal. In the soft morning light they seem insubstantial, while water, land and sky blend into one another in a way that lends the painting an ambivalent mood, serene and yet menacing. Will these ghostly airmen return from their mission?

After his visit to the Isle of May, Ravilious followed John Nash's suggestion and travelled to the Royal Naval Air Station in Dundee, where he discovered the Supermarine Walrus. This ungainly amphibious biplane had been designed – surprisingly enough – by R. J. Mitchell, creator of the Spitfire, and unveiled in 1933. The first aircraft specifically designed to be launched by catapult from a warship, the Walrus was robust but also capable of loops, bunts and other aerobatic feats if the pilot did not mind being soaked by water from the bilges.

During the war five submarines were sunk by Walrus flying boats, but it was in air-sea rescue that the craft gained its reputation; pilots would on occasion land to rescue airmen in circumstances when take-off was impossible. Instead they would taxi miles across the open sea and then, on reaching land, lumber up a slipway. Ravilious was captivated by this eccentric plane.

'I spend my time drawing seaplanes,' he wrote to Dickey from Scotland, 'and now and again they take me up... I do very much enjoy drawing these queer flying machines and hope to produce a set of aircraft paintings... What I like about them is that they are comic things with a strong personality like a duck, and designed to go slow. You put your head out of the window and it is no more windy than a train.'

Ravilious loved to stick his head out of a train window, and was forever losing hats and caps in the process, so perhaps it was not surprising that he took to flying. Dressed up in flying-suit, parachute and Mae West – a kind of inflatable life jacket – he would crawl in at the nose and sit in the co-pilot's seat. Then he was offered a still more exciting opportunity to travel in the rear gunner's seat, which was uncomfortable but had the best view.

'The only drawback,' he wrote to Helen Binyon, 'is that I have to do a number of simple (?) mechanical things with hatches when the seaplane comes down on the water. How trusting they are!'

In the event he opened his parachute by mistake and became entangled in yards of silk and string, but he had discovered a new source of inspiration. To fly and to sketch from planes in flight became his overriding ambition.

Morning on the Tarmac, 1941, watercolour, 49.5 x 54.6 cm, Imperial War Museum, London.

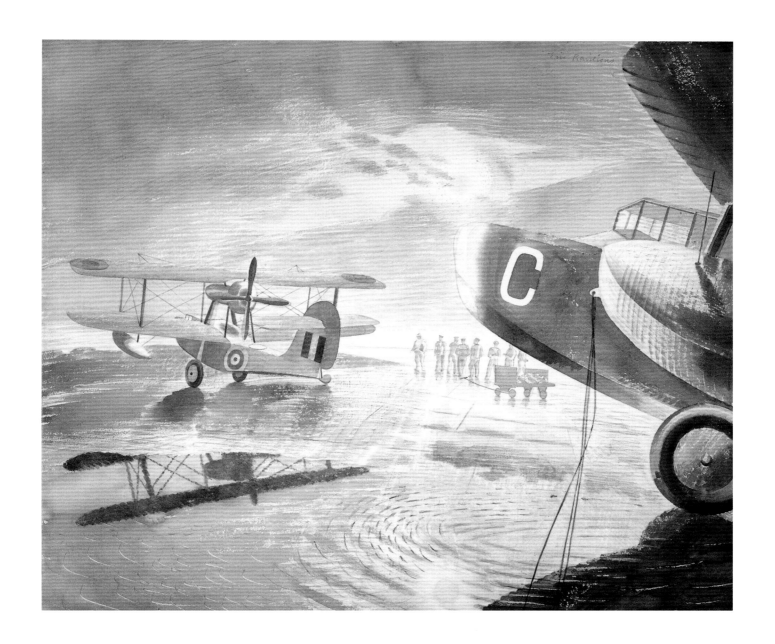

RNAS SICK BAY, DUNDEE

While Ravilious was staying in Scotland his children succumbed to whooping cough, which was then a potentially fatal disease. Indeed John, and Anne, who had been born only in April, almost died. After a move in the spring, Tirzah was now living at Ironbridge Farm near Shalford in Essex, with three children, two of them under two. Remote and lacking in amenities, the house was gorgeous in summer, but scarcely habitable in winter. Christine Nash noted that her old friend seemed homesick.

So it is intriguing to imagine the artist's thoughts as he painted this tranquil interior – the very picture of recuperative rest. From the lovingly drawn counterpane with its naval motif of crown, wreath and anchor, to the well-worn wooden chair, this sick bay with its sweeping view of the River Tay is one designed for a relaxing convalescence. Outside the window, the familiar, duck-like Walrus seaplanes ride at their moorings, while the room is filled with pearly light from the river. For the relatives and friends of Allied airmen this must have been a reassuring vision, with the flying boats promising rescue and the sick bay recovery.

The Dundee base, known as HMS *Condor II* in official circles, was a rudimentary affair, with a shed for the flying boats, a pillbox for defence and a mess nearby in a former girls' school. Airmen training with the Fleet Air Arm as observers were stationed at HMS *Condor,* some miles to the east at Arbroath, where they flew in Lysanders and Swordfish; they then travelled to Dundee to experience the peculiarities of the Walrus. With Bell Rock a convenient marker 25 miles into the North Sea, trainee airmen learnt everything from navigation to the art of crank-starting a stalled engine as the plane pitched and tossed on the waves. The pilots were of necessity patient and good-humoured, too old for active service and devoid of martial pretensions. Ravilious liked them immensely.

'These planes and pilots are the best things I have come across since this job began,' he enthused. 'They are sweet and have no nonsense (naval traditional nonsense and animal pride).'

As an artist raised on the south coast, who had so often painted ports and ships, it made sense for Ravilious to join the Admiralty in 1939, but two years on it was clear that planes and pilots were to be his greatest wartime inspiration. Although feeling the tug of home – he returned just in time for Christmas – he was full of plans and ideas. In early January the WAAC recommended that he be sent to Russia – as he had requested – to begin another six-month contract, this time with the RAF.

RNAS Sick Bay, Dundee, 1941, watercolour, 48.8 x 54.2 cm, Imperial War Museum, London.

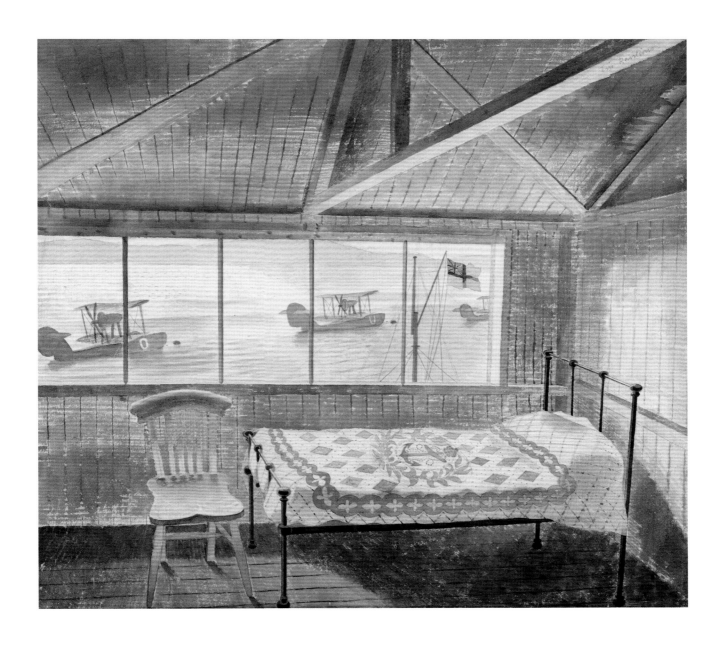

SPITFIRES AT SAWBRIDGEWORTH

Few aeroplanes are more celebrated than the Spitfire, painted here by Ravilious at RAF Sawbridgeworth. Designed in Southampton by the makers of the Walrus, and modelled on an earlier seaplane, this was the fighter most feared by German pilots. However, there were no Spitfires stationed at this Hertfordshire base in 1942, which makes these aircraft something of a mystery.

But how did Ravilious find himself here, only a few miles from home? Early in January he was entertained by Lord Willoughby de Broke, a Wing Commander in the RAF, to a lunch at Boodles which Ravilious – a fan of Jeeves and Wooster – described as 'pure Wodehouse'. Lord Willoughby vetoed his Russian plans, suggesting instead a trip to Ireland. Then that too failed to materialise. RAF Gatwick was the next destination proposed, then the posting changed and Ravilious was sent instead to York, where he flew in a Lysander over Greta Bridge, the subject of a favourite painting by John Sell Cotman.

Then, on 7 March, came dire news. Tirzah had recently undergone minor surgery but was now being rushed into hospital for an emergency mastectomy. Ravilious went home at once and worked on his York paintings while Tirzah convalesced and her mother held the fort; his request for a transfer to a local aerodrome was granted and, after a

short and unrewarding stint at RAF Debden, he arrived at Sawbridgeworth in early May. He liked the place immediately, as he explained to Tirzah:

'The other was a very fine 17th Century house with a splendid garden, huge and luxurious; this place is more primitive than most and my hut is I think made of cardboard… but it is my line and the other isn't.'

This was not a conventional RAF base but the home of 2 Squadron. Formed in 1912, the world's oldest squadron began to specialise in reconnaissance during the Great War, and took up this role again in 1939. After the Fall of France, 2 Squadron moved to the hastily constructed airfield at Sawbridgeworth, where it flew American fighters that were too slow for European combat but ideal for observation. The first Mustangs arrived shortly before Ravilious, and in July these new planes were showcased during a press day attended by American journalist Quentin Reynolds and photographer Charles Brown.

2 Squadron had no Spitfires until later in the war, yet Ravilious painted them at the base – the nearest is shown protected by the wall of a blast pen installed to minimise bomb damage. The squadron's Operations Record Book holds the answer – that on 1 August 1942 the Spitfire squadron from North Weald visited, so that the Mustang pilots could practise fighting tactics.

Spitfires at Sawbridgeworth, 1942, watercolour, 45.7 x 61.9 cm, Imperial War Museum, London.

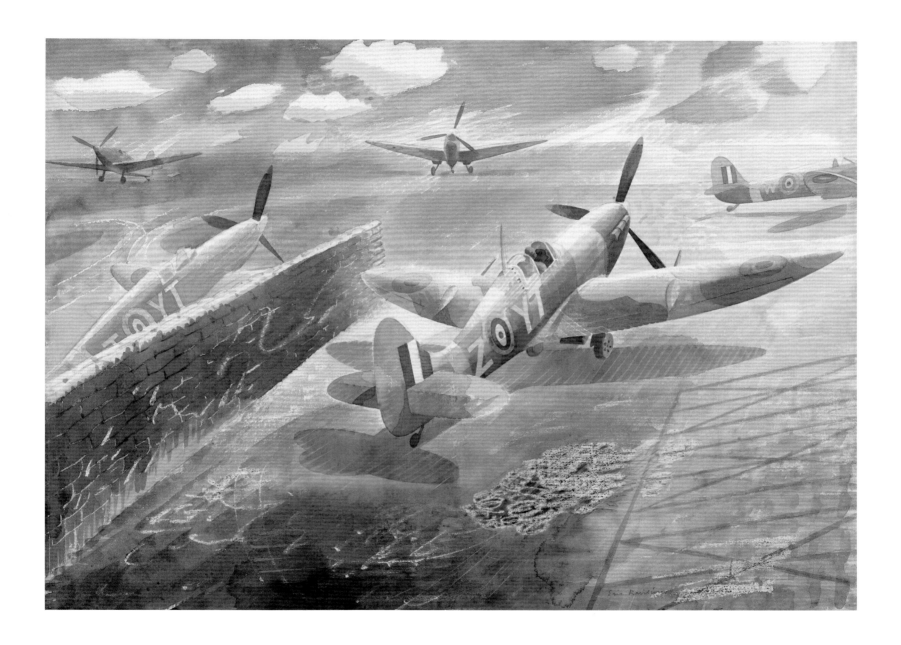

CORPORAL STEDIFORD'S MOBILE PIGEON LOFT

At first sight this is a strange subject for a War Artist. A squad of soldiers can be seen through the open doorway, but they are distant and indistinct compared to the pigeons in the foreground. Vividly drawn, with individual markings, colouring and even mannerisms, the birds are the focus of the artist's gaze. And although the interior is lined with cages, the pigeons move around freely. This is a sanctuary, not a prison.

At Sawbridgeworth Ravilious painted diverse subjects, from Tiger Moths in flight to men having breakfast. Free to roam, he made detailed studies of a sergeant demonstrating a machine gun and painted the interiors of the Operations Room and Mess Room. And he made this extraordinary watercolour of a mobile pigeon loft, the last in a career-long series of interiors that included greenhouses, farmhouse bedrooms and the shops of *High Street*. Some years before, Ravilious had illustrated a new edition of *The Natural History of Selborne,* and here he shows an attention to detail that Gilbert White might have admired. The loft itself – an antique vehicle resembling a stagecoach – is portrayed with characteristic care, from the mottled ceiling to the wire cage doors.

In fact the birds were service personnel in their own right. Pigeons were carried by all bomber crews in case of emergency, and thousands of lives were saved by birds that flew home with the coordinates of a crash site. Over a quarter of a million pigeons were used by the armed forces, police and civil defence forces during the war, and they were considered such a valuable asset that pigeon corn was rationed and racing banned for the duration of hostilities, while peregrine falcons and other predators were culled in coastal areas so that the birds could return home safely.

Of the fifty-three Dickin Medals awarded to animals for bravery during the war, thirty-two went to pigeons, such as that to Billy (NU.41.HQ.4373), 'for delivering a message from a force-landed bomber, while in a state of complete collapse and under exceptionally bad weather conditions, while serving with the RAF in 1942'.

The birds of 2 Squadron, trained by pigeon racer Joe Stediford, made a particularly important contribution to the war effort, reporting enemy positions to base at times when it was essential to maintain radio silence. So this was a perfectly proper subject for a War Artist; the resulting painting is charming and historically valuable. It reminds us that, though we may think of World War II as a modern war of machines, there were times when men's lives and even the conduct of the war depended on the homing instincts of the humble pigeon.

Corporal Stediford's Mobile Pigeon Loft, 1942, watercolour, 47.3 x 55.2 cm, Whitworth Art Gallery, Manchester.

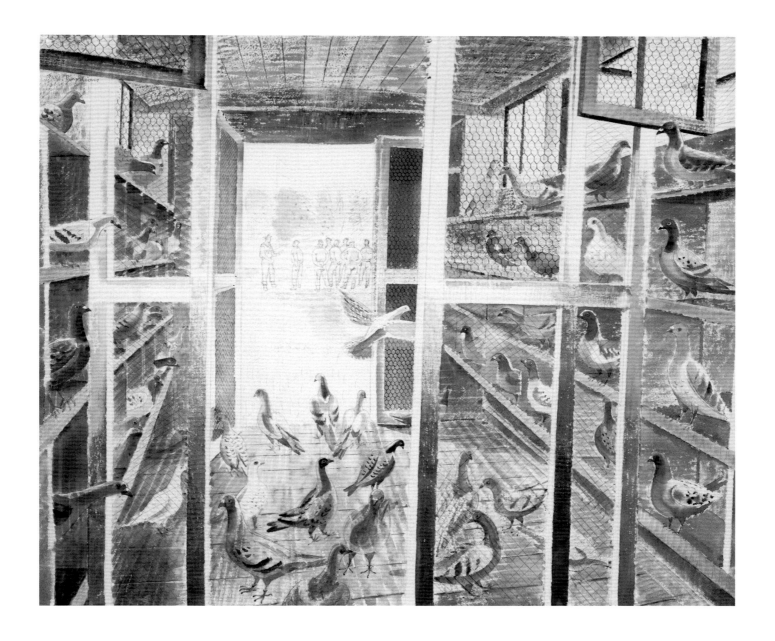

RUNWAY PERSPECTIVE

Above a simple runway, against a backdrop of summer clouds, a plane climbs into the sky. Through the summer of 1942 Ravilious wrestled with the peculiar difficulties of painting aircraft in flight – the rapid motion of the planes and the open, featureless space of runway and sky. Here he finds form in the runway itself, a crude track made of coconut matting overlaid with pegged-down wire, with a few wisps of cirrus to balance the long, receding stripes. In the distance is the spire of Thorley church, while Mathams Wood can be seen on the left. Otherwise there is nothing to interrupt the vista of plain and sky, save the Tomahawks overhead.

It is a curious quirk of war that Ravilious should have preserved for posterity an airfield that played such a minor role. Sawbridgeworth was no Biggin Hill. Although a landing strip existed before the war it was in 1940 that Wing Commander Geddes, CO of 2 Squadron, picked the flat stretch of farmland for his new base. In a process repeated across the country, the neighbouring buildings – Great Hyde Hall and Shingle Hall – were requisitioned, a perimeter road and defensive positions constructed and a makeshift runway laid. Pre-cast concrete huts were added later, some of which still survive today. Theatre designer Laurence Irving, who was stationed with his squadron at Sawbridgeworth in 1943, found the living quarters 'damp and penal'. However, the temporary, primitive quality of the base appealed strongly to Ravilious.

'The hardships here are just the sort I like,' he told Helen Binyon, 'lovely wooden huts all yellow and green with latrines among the trees, a very hard bed with calico sheets almost like canvas, no pillow, table, chair or looking glass for shaving. It looks so nice and bare and sunny… It is tricky shaving by touch and you need an old blade that won't cut.'

Besides, in recompense for discomfort he did have his favourite beverage.

'The brown tea at 7 is the most powerful "gunfire" I've come across since war began,' he enthused. 'The batman boils it on his stove.'

As the weather improved he began flying regularly in the Tiger Moths used by the flying school that shared the base with 2 Squadron, and he once again took up the challenge of marshalling the 'clouds and patterned fields and bits and pieces of planes' that could be seen from an aircraft in flight. In June he travelled with a group of trainee pilots to Westonzoyland in Somerset.

'It was more lovely than words can say flying over the moors and the coast today in an open plane,' he wrote to Tirzah, 'just floating on great curly clouds and perfectly still and cool…'

Runway Perspective, 1942, watercolour, 45.7 x 54.2 cm, Imperial War Museum, London.

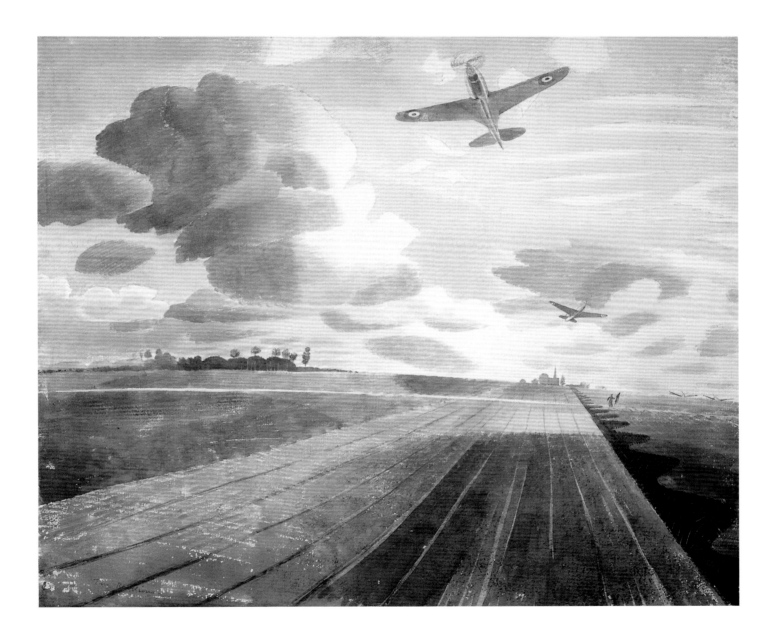

HURRICANES IN FLIGHT

By July 1942 Ravilious was becoming adept at drawing from the air. This painting, from the rear cockpit of a Tiger Moth, contrasts the fixed structure of the wing with the Mustangs — not Hurricanes as the title suggests — banking and twisting beyond. The fields, woods and roads below are shown in intricate detail, while the curving lines of the camouflaged wing counterpoint the shapes of the land, creating a harmonious vision that reflects the pleasure Ravilious felt in flight.

Not that he was unaware of its dangers. While at RAF Westonzoyland the artist saw one of the trainee pilots — a man he knew and liked — crash to his death in the sea, and Helen Binyon recorded how deeply disturbed he was by the incident when she saw him shortly afterwards. Indeed, this was a sad and difficult time for Ravilious, who had lost his mother the previous year. His father Frank was seriously ill, while Tirzah had to undergo a further operation.

His work, however, was going well. A posting to the Norwegian Squadron in Iceland had been proposed and accepted, and for once his plans progressed smoothly. In August he went to a leaving party held for E. M. O'Rourke Dickey, the popular WAAC secretary, and met Kenneth Clark, who approved of the trip and told Ravilious 'he thought highly of the Norwegian pictures'.

On 28 August Ravilious flew to Reykjavik, before travelling by road to RAF Kaldadarnes, on the coast. From this strategic position the Hudson aircraft of 269 Squadron provided air cover for Allied convoys, but sudden, violent storms took their toll. On 1 September, the day he arrived, a Hudson failed to return from a mission, and when three planes took off at dawn the next day to search for survivors Ravilious went too. Perhaps he intended to sketch the rescue, but in the event his aircraft too disappeared and, after a fruitless four-day search, Eric Ravilious was reported missing along with Flight Lieutenant A. C. Culver DFM, Pilot Officer N. J. Graves-Smith, Flight Sergeant W. H. R. Day and Flight Sergeant G. N. Barnes.

Tirzah received the telegram on 5 September, and knew that he was lost. A couple of days later, among the letters of condolence, came one written in pencil and dated 1 September.

'My darling Tush,' it began, 'I do hope you feel well again.' And in his usual bright, observant style, Eric described his experiences of Iceland so far — restaurant tables piled high with food, 'a splendid narwhal horn' and a night without sheets or pillow. This letter was his last communication with the world but the paintings remain, a personal record of war by a brave, charismatic man.

Hurricanes in Flight, 1942, watercolour, 43.0 x 57.0 cm, private collection.

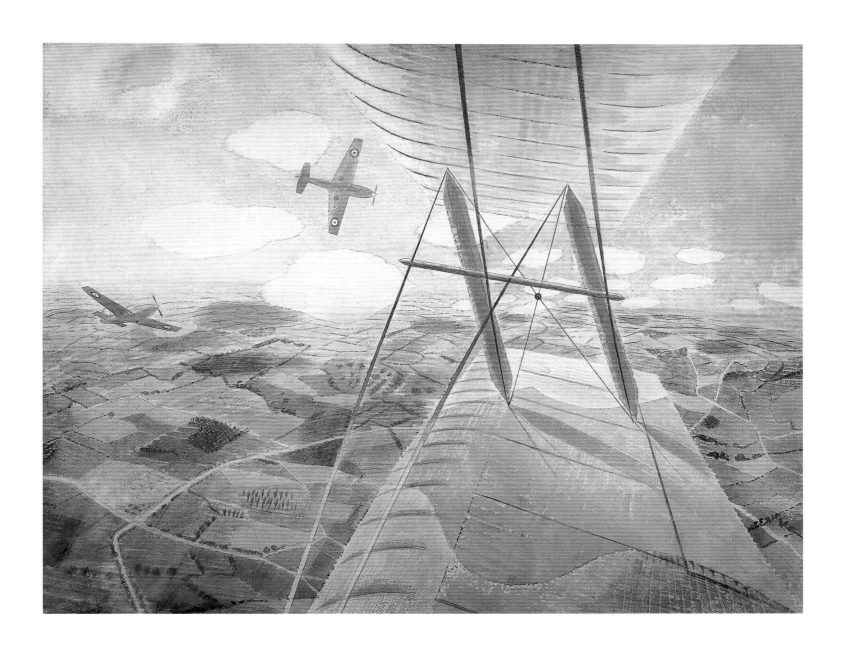

First published in November 2010 by
The Mainstone Press, Sparham, Norwich NR9 5PR
www.themainstonepress.com

ISBN 978-0955277740

Edited by Tim Mainstone / Design by Webb and Webb
Printed in England by Empress Litho Limited

The wood engravings by Eric Ravilious used throughout *The War Paintings*
were cut for a naval publication *c.*1942

We are indebted to Anne Ullmann, the artist's daughter, and to Simon
Lawrence of The Fleece Press. Quotations from the correspondence of Eric
Ravilious are mostly taken from *Ravilious at War* published by The Fleece Press
in 2002. We would like to thank Robin Ravilious, Alan and Susanna Powers,
Adrian Corder-Birch, Brian Webb, Nigel and Iris Weaver, Gordon Cummings,
Gordon Cooke and Lt Cdr R. J. Hoole of the Minewarfare & Clearance Diving
Officers' Association for their assistance in researching the book. Lastly, special
thanks to Miranda, Ollie, Harry and Lucy.